Drawing Across The Lines

Pamela Calore

www.drawingacrossthelines.org
https://drawingacrossthelines.wordpress.com
https://pamcalore.com
pjc.documentary@gmail.com
United States/Europe

Storytelling Through Art

Florida Art Education Association (FAEA)
Conference 2021
Storytelling Suitcases and Shrines

The workshops will be presented by Pamela Calore

Schedule:

Thursday, October 14th, 2021

10:30 am

Sunday, October 17th, 2021

8:00 am

Caribe Royale, Orlando, FL

This booklet was created for the 2021 FAEA conference, and my workshops are sponsored by the Monroe County School District serving the Florida Keys, where I teach high school Art Education.

The booklet contains a collection of lesson plans that have been gathered from workshops and art classes geared towards social integration in schools and in communities. The storytelling art projects exemplify authentic stories depicted in small maletas (suitcases), shrines, prints, and books that foster critical reflection of struggles and successes to maintain the language, culture, and integrity of the family. A personal shrine is like a memory in a box. Students will make their own shrines using their own personal stories.

1

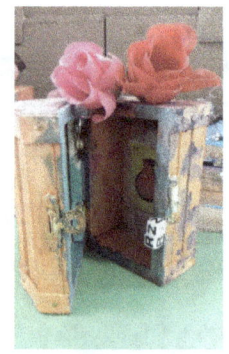
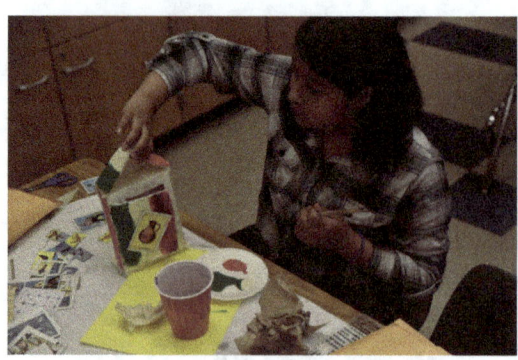
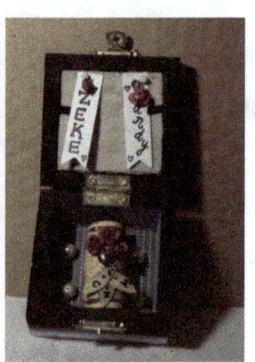
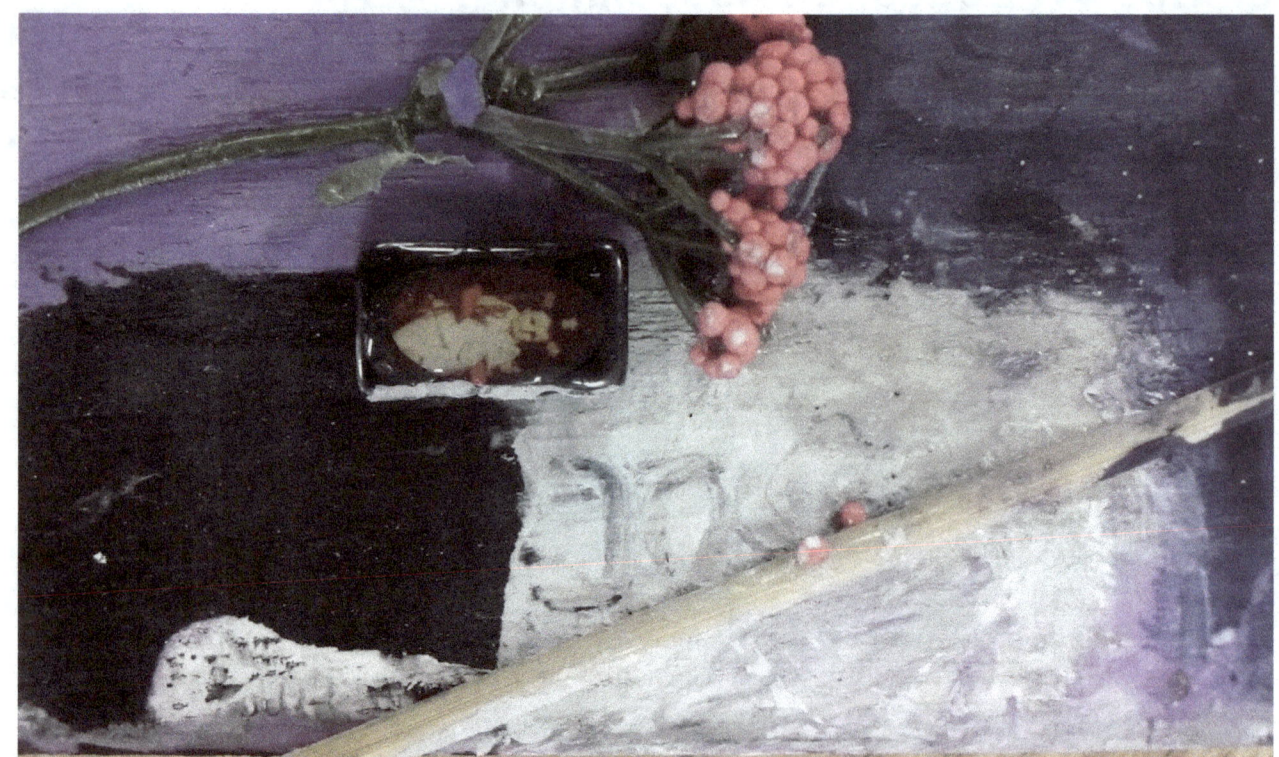

Table of Contents:

Acknowledgements	3
Introduction	4
Creating a Personal Shrine and Memory Box	6
Additional Cultural Immersion Lessons	12
Japanese Stab Book Binding	15
Paper Marbling	17
Block Printing	20
Creating a Shadow Puppet	23
Environmental Self Portrait	30
Bibliography	35

Acknowledgments:

For the project in Malta, I was granted security clearance with the Ministry for Home Affairs, National Security and Law Enforcement and the Agency for the Welfare of Asylum Seekers, which enabled me to teach art classes at two refugee camps for families in Hal Far and in a camp for men in Marsa.

Through these experiences, data was collected from the refugees' artwork, photographs and interviews. The outtake was published in an article "*Living on the Streets in Istanbul*" by New America Media and presented through two lecture workshops which I taught, *Storytelling Through Migrant Eyes* and *My Life is My Message*. The workshops were part of an incentive grant awarded to and directed by Dr. Ana Hernandez, Associate Professor of Multilingual and Multicultural Education, and Monica Nava, Migrant Ed. Region 9, California State University, San Marcos, 2019.

The project lesson plan template is acquired from an ESOL course taught by Professor Ryan Van, Florida Southern College, 2021.

Introduction:

It is my belief that art has a direct link to the heart. The universality of art, to express emotion and build on the human experience, suggests art itself has the potential to cut through the rhetoric of discrimination, isolation and othering enforced during times of war or any crisis that forces people to flee from their homes or to be feared based simply on difference.

Background and Approach:

I am currently teaching art education with the Monroe County School District and am also a research student at the National College of Art and Design in Dublin, Ireland. My projects focus on global migration, trade and labor. My main goal is to discover ways in which art can bridge the gap between cultural divides and to demonstrate the capacity of art to build connection and erode the rhetoric of fear of the other.

In 2015 I began a pilot study where I documented the conditions of refugees in three different countries: those living on the streets in Istanbul, Turkey; in the refugee camps in Malta; and in resettlement communities in Sutera, Italy.

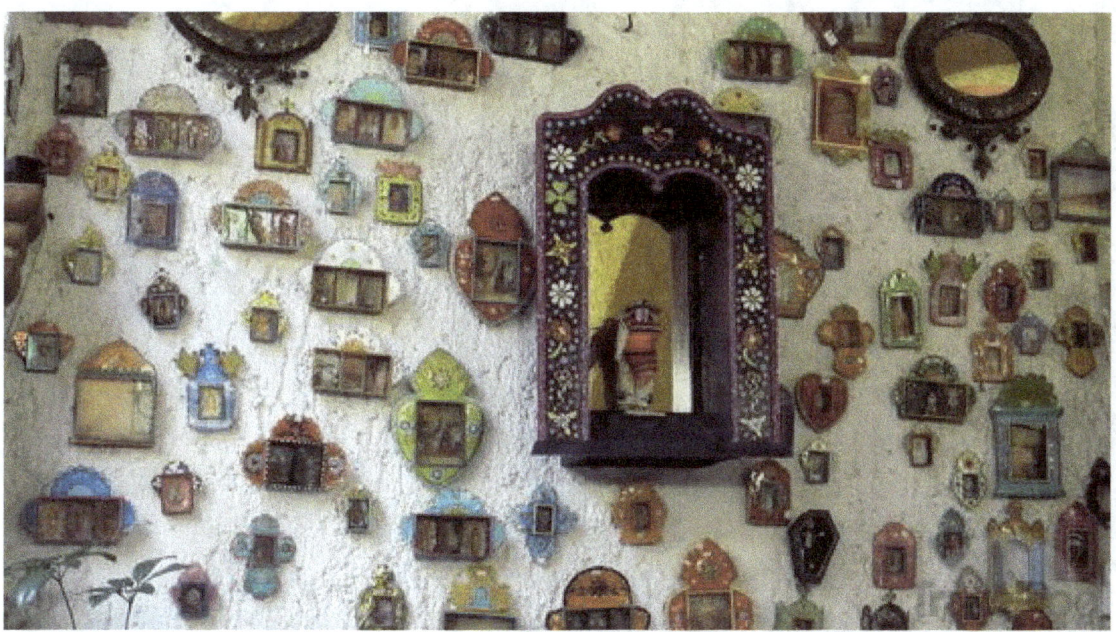

Shrines in the Ta' Pinu Basilica, Island of Gozo. Photo by Pamela Calore, December, 2015.

5

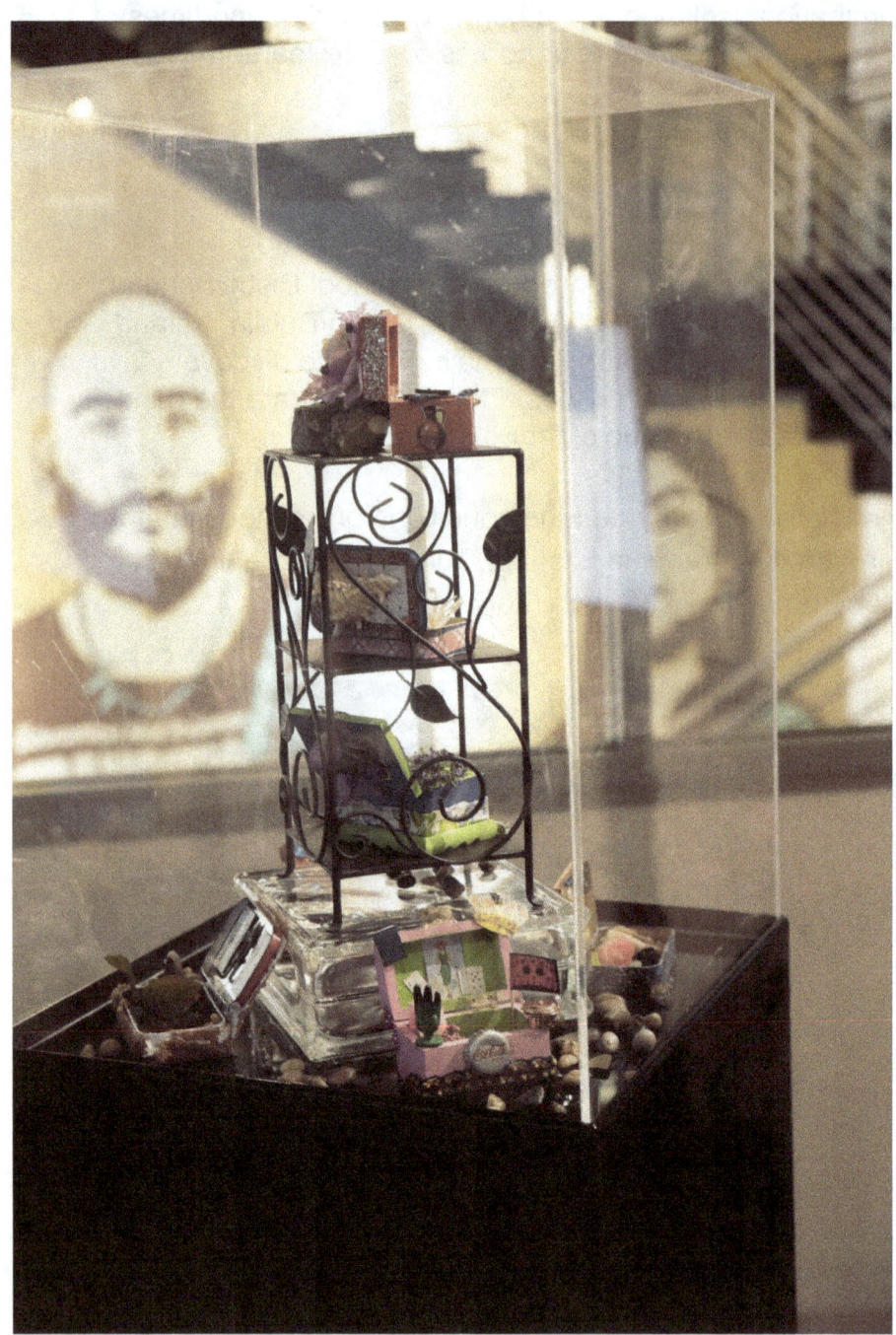

FL Standards (Academic Standards)	Creating A Personal Shrine: Student Achievement (Learning) Objectives (SAO)	Summative Assessment/Evaluation Questionnaire:
Big Idea VA.912.C: Critical Thinking and Reflection **Enduring Understanding** VA.912.C: Cognition and reflection are required to appreciate, interpret, and create with artistic intent. VA.912.C: Assessing our own and others' artistic work, using critical thinking, problem solving, and decision making skills, is central to artistic growth. VA.912.C: The processes of critiquing works of art lead to interpreting and responding to Art. VA.912.C: Development of skills, techniques, and processes in the arts strengthens our ability to remember, focus on, process, and sequence information. VA.912.S: Through purposeful practice, artists learn to manage, master, and refine simple, then complex, skills and techniques.	The students will demonstrate understanding of mixed media art projects and will draw models. A personal shrine is like a memory in a box. Learning Objectives: The art project exemplifies authentic stories depicted in small maletas (suitcases) and shrines. 1. Learn the process of building a personal shrine 2. Understand art making terms such as what "medium" means art making. 3. Understand how to use various materials in the process of building a shrine. 4. Understand the process of self-reflection on our personal family history. 5. Understand how to communicate personal stories with art making and writing.	1. What is a personal shrine? 2. What does the term "medium" mean in art making? 3. What kind of materials are used in the process of building a shrine? 4. What does it mean to reflect on our personal family history? 5. Will a personal shrine communicate our stories?

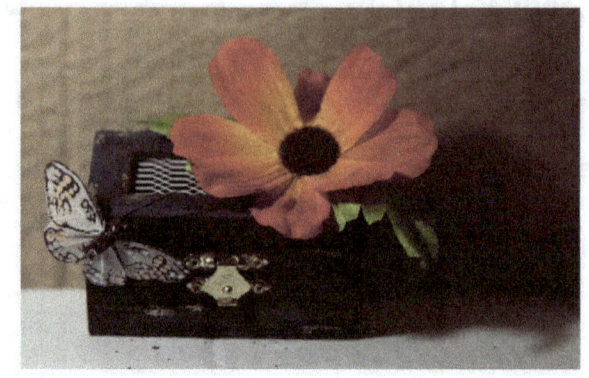
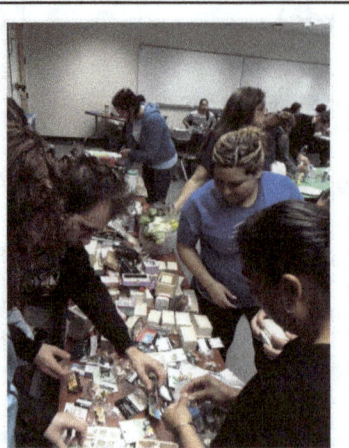
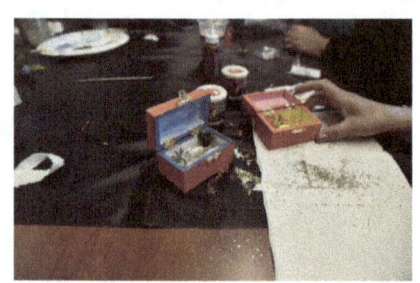
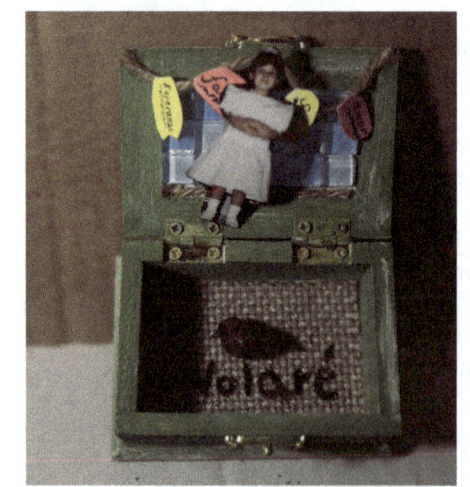
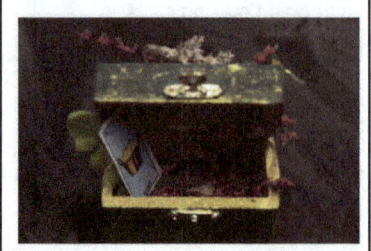
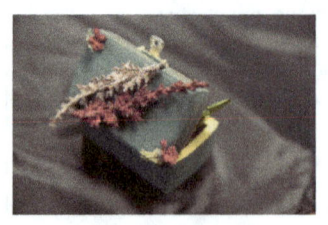
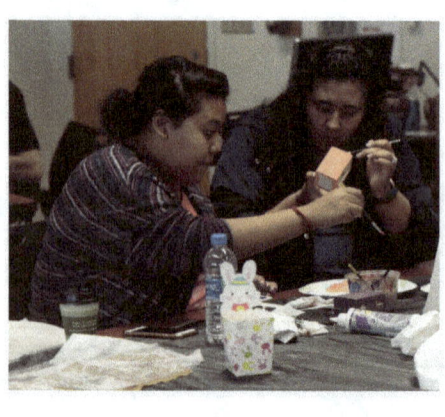
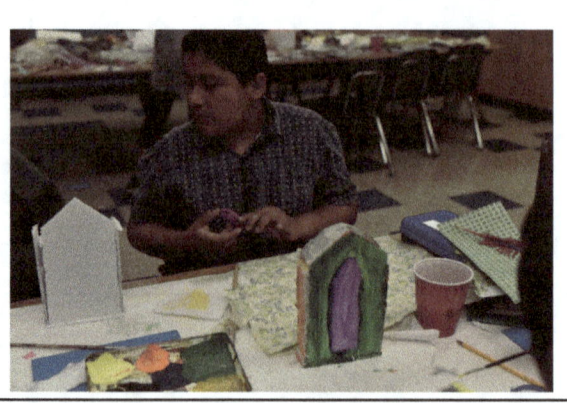
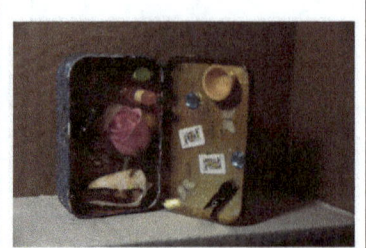

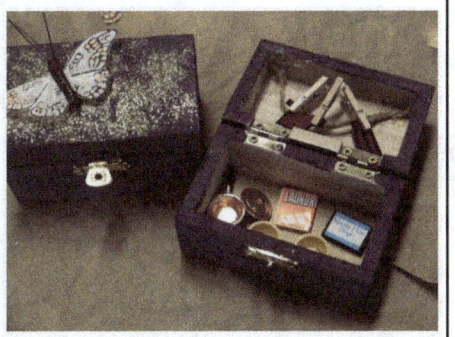	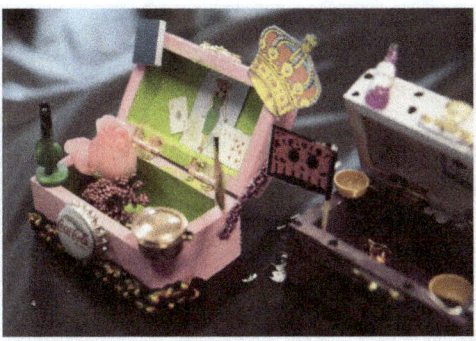	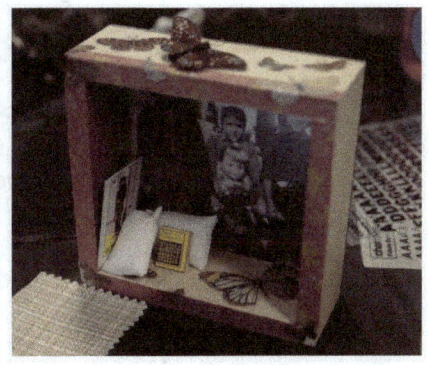
	A pretest and posttest will be provided for students to check previous knowledge and to assist with measuring learned objectives in the lesson.	
ESOL strategies - List taken from ESOL course at Southern Florida College. Codes: LY The student is an English Language Learner and is enrolled in classes.	1. Provide a climate of warmth and caring which nurtures a sense of comfort. 2. Seat the student close to the front of the room. 3. Establish a daily routine in your classroom and prepare the students for any changes. 4. Use as many of the senses (seeing, hearing, touching, smelling and tasting) as possible to present information to students.	

Specifically designed for ELLs.	**Technology support strategies:** 1. Teach through modeling rather than giving directions. 2. Assign work in groups with native speakers of English. 3. Have a student surpass his/her own previous record rather than the score achieved by a rival. 4. Select software that has been proven effective for the purpose of using content to enhance language development.
Materials/Tech/Eqmt/ E-Lrng	* Shrine images, history and fun facts * Napkins * Acrylic paint * Markers * Glue * Foam core and/or boxes * Cardboard * Found objects * Pictures * Text * Varnish/Mod Podge * Wood boxes

Vocabulary	**Texture**- the feel, appearance, or consistency of a surface or substance.
	Color- the property possessed by an object of producing different sensations on the eye as a result of the way the object reflects or emits light.
	Space- the dimensions of height, depth, and width within which all things exist and move.
	Multi-cultural- relating to or constituting several cultural or ethnic groups within a society.

Instructional Strategies	**Procedure:** 1. Select a small box 2. Cut out cardboard for the roof 3. Glue on the roof 4. Paint the box using a white acrylic paint as a base/ let dry for 10 minutes 5. Napkin transfer technique 6. Draw on the box with Sharpies and paint pens- flowers and birds 7. Glue personal effects/photos 8. Paint the box with acrylic color paint 9. Varnish with Mod Podge

Wrap-up/Closure	List the FL Standard(s) and learning target(s) in this section:	Estimated Time: 5 days
	Wrap-up/Closure: Exhibit of the artwork and oral presentation of their work.	
	Higher Order Questions/Activities (TPI 2.2)	Students will analyze their work and discuss the work created.
	Formative Assessment (TPI 2.2) Posttest and reflection.	The finished work will be graded as a performance-based assessment.

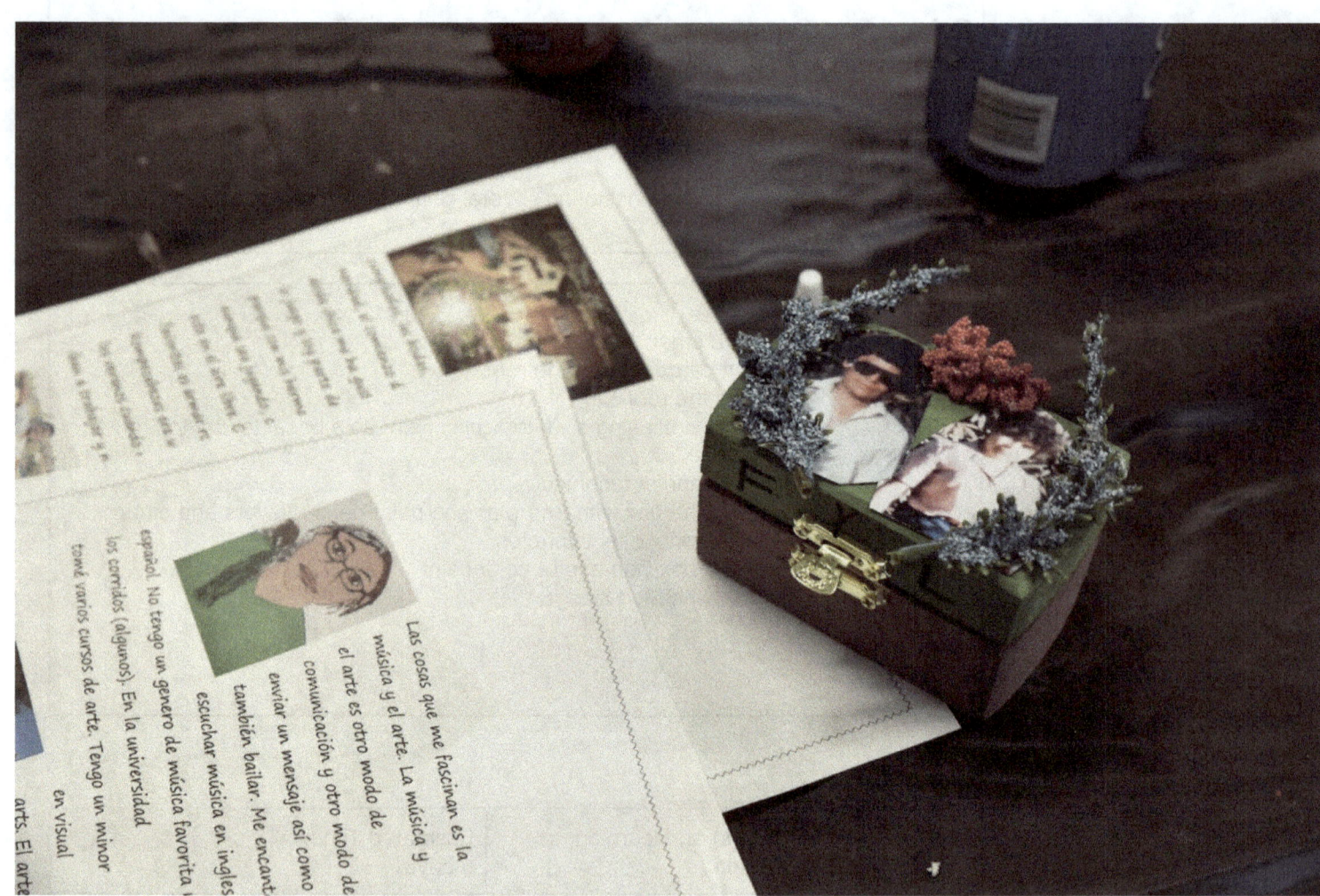

Additional Cultural Immersion Lessons

Total Length of Lesson: 5-10 day lessons

Subject Area/Topic of Lesson:

Course Number/Title: Stab Binding, Block Printing and Shadow Puppet Play

Grade Level:

- 6-12 grade
- ESE students
- ELL students
- Gifted students

FL Standards (Academic Standards)

Big Idea **VA.912.C:** Critical Thinking and Reflection

- Enduring Understanding 1 **VA.912.C.1** : Cognition and reflection are required to appreciate, interpret, and create with artistic intent. read more
- Enduring Understanding 2 **VA.912.C.2** : Assessing our own and others' artistic work, using critical-thinking, problem-solving, and decision-making skills, is central to artistic growth. read more
- Enduring Understanding 3 **VA.912.C.3** : The processes of critiquing works of art lead to development of critical-thinking skills transferable to other contexts.

Student Achievement (Learning) Objectives:

1. Learn the history of other cultures; in this case, the history of the Silk Road. (The new Silk Road includes thirty-two countries, AH1 highways, and it begins in Japan).
2. Understanding what the term "medium" means in art making.
3. Understanding of art techniques that are used to create Japanese block printing.
4. Understanding of the making of a shadow play.
5. Understanding of stories that are performed with shadow puppets.
6. How to create a book and stab binding.

Summative Assessment/Evaluation of Silk Road

Post-Art Assessment:

8. What does the term "medium" mean in art making?
9. What art techniques are used to create Japanese block printing?
10. What is a shadow puppet?
11. What kind of stories are performed with shadow puppets?
12. What is stab binding?

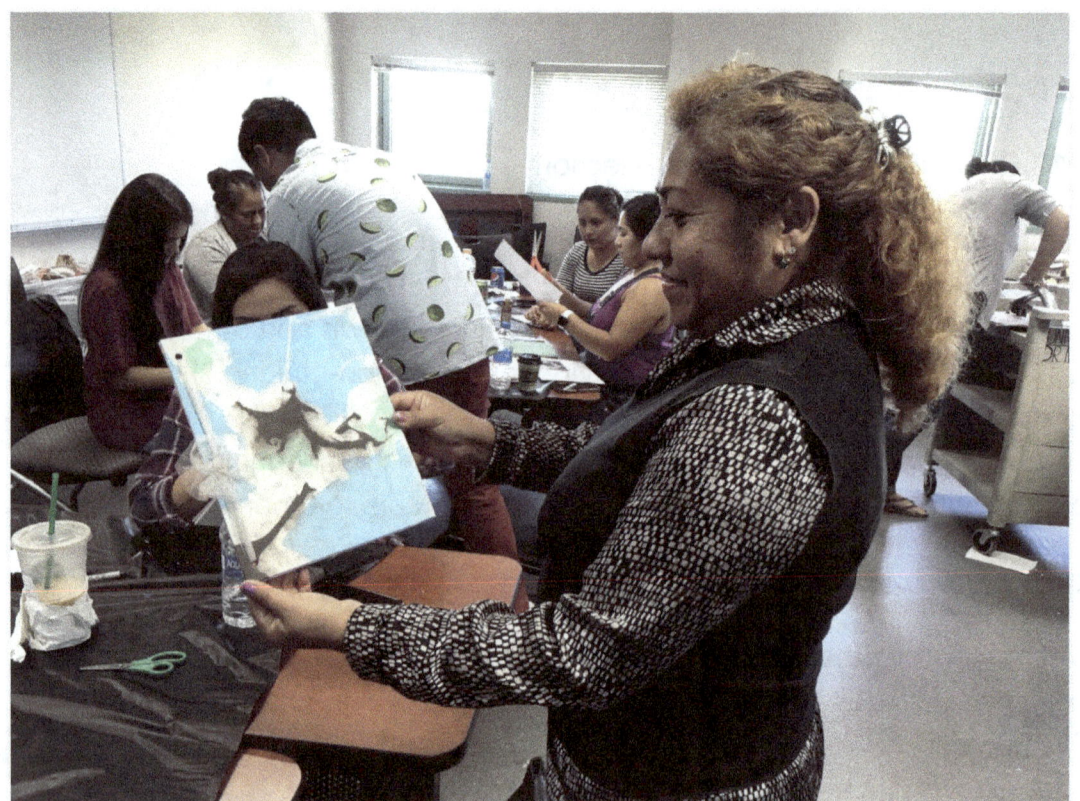

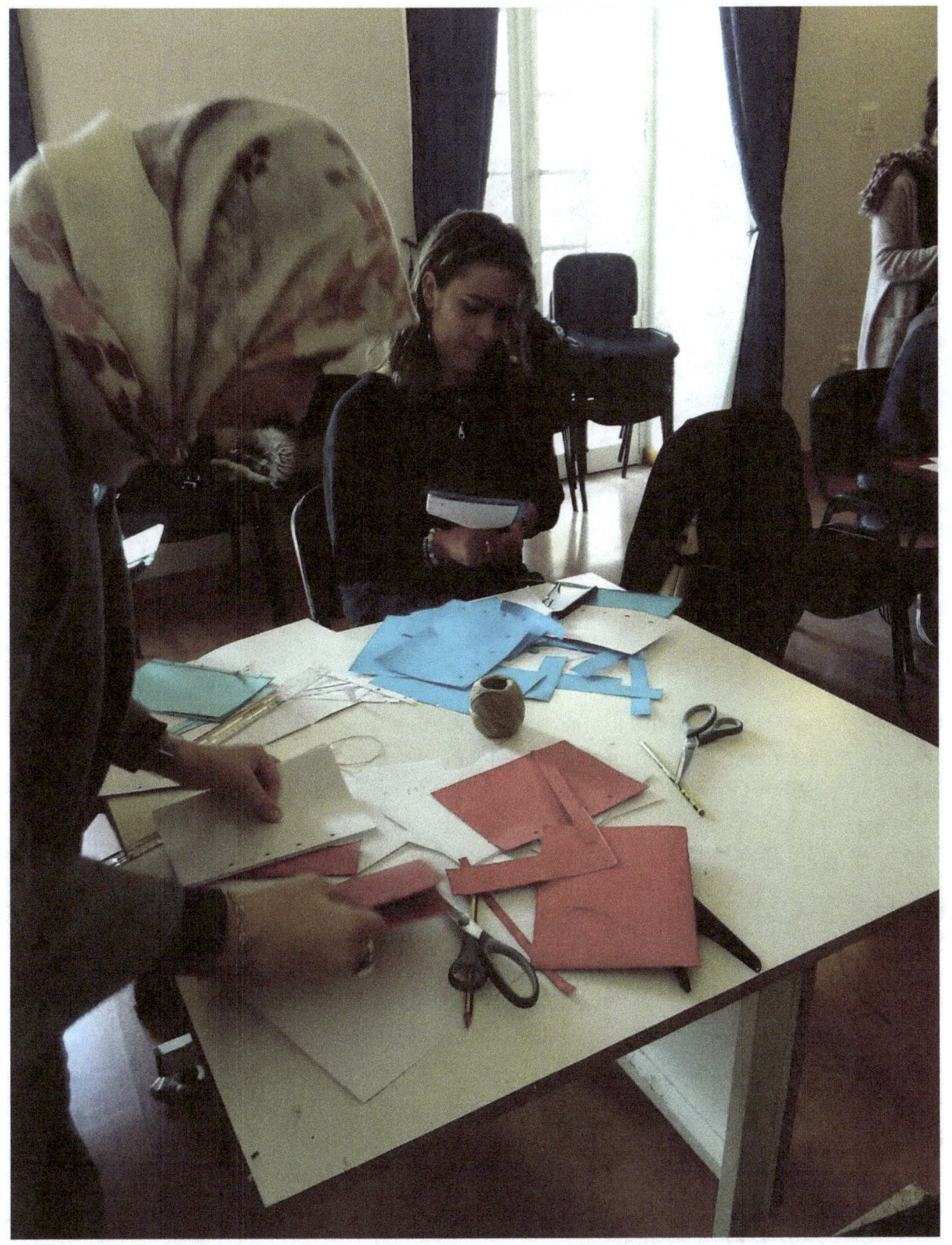

Japanese Stab Book Binding

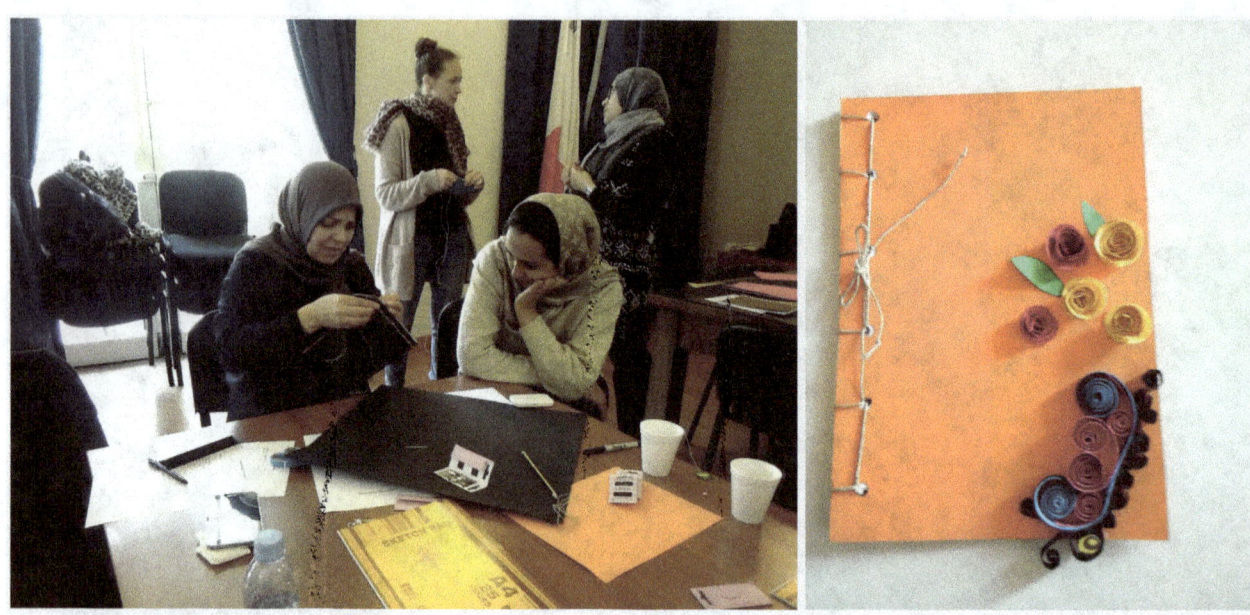

Introduction:

Stab binding originated in China in the 14th century. It was practiced in China, Japan and Korea. This binding technique does not require adhesives. The entire process is done by sewing with string.

Some glue will be needed for the covers.

Materials:

- Three sheets of 18in x 24in (approx 46cm x 61cm) drawing paper or sketchbook paper
- Sheet of thick handmade paper or cardstock
- Waxed linen thread
- Bookbinding needle
- Awl
- Ruler
- Triangle (or set square)
- X-Acto knife (or craft knife)

- Bone folder
- Construction paper
- Cover options- decorative paper, leather, cloth

Vocabulary:

- Bookbinding
- Stab Binding
- Carving
- Sewing

Activity:

- Measure and cut paper to desired book size.
- Punch 5 holes on one side of the paper for binding.
- For the book cover you will need thin cardboard or poster board.
- Measure to the desired size.
- Glue fabric or paper to the cardboard and fold the edge over the board.
- Corners can be folded in and glued down.
- Punch five holes along one side of the cover on both covers, making sure the hole lines up.
- Place a printed design paper or construction paper on the inside of the cover for a clean finish.
- Line the covers up with the paper.
- Next, thread the large sewing needle with thick thread, yarn or string.
- Start on the third hole.
- Leave a small amount of thread for tying at the end.
- Thread around every other hole on one side to the end, then return and thread the remaining holes.
- Tie a knot.

For more information on the directions of stab binding, please review the fundamentals here:

https://crafts.tutsplus.com/tutorials/bookbinding-fundamentals-basic-stab-binding--craft-10250

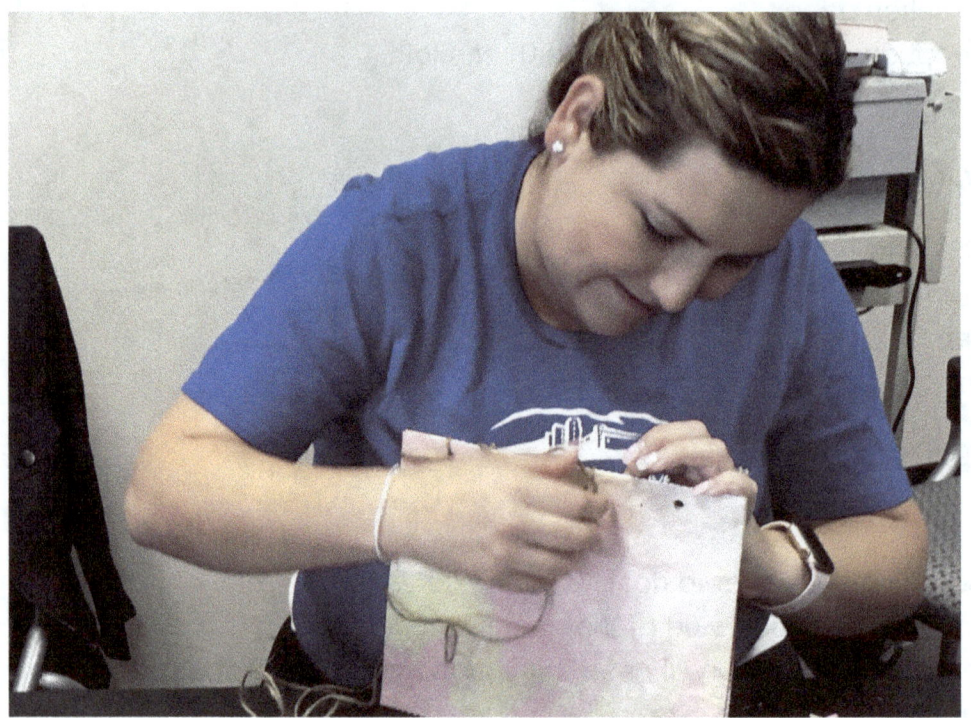

Paper Marbling:

Covers can be created by using the methods of paper marbling techniques.

Materials:

- Rice paper
- Computer paper
- Aitoh Origami Marbling Kit, 12 ml (Pack of 6)
- Plastic container
- Paper towel
- Water

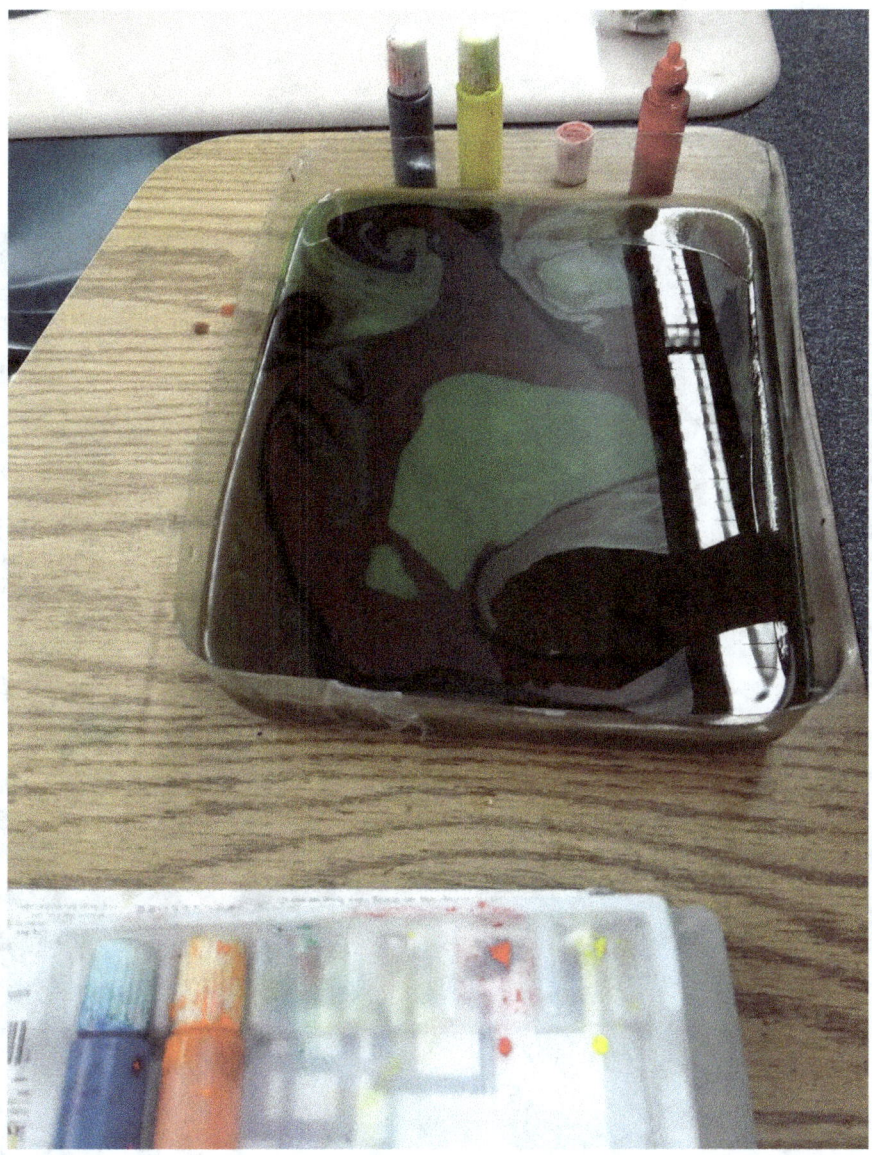

Place the droplets of ink on the surface of the water and slip the paper just underneath the ink drops. Try not to place your fingers or any items into the water other than the paper. Once the ink falls below the water's surface, the effectiveness of it is reduced.

Block Printing

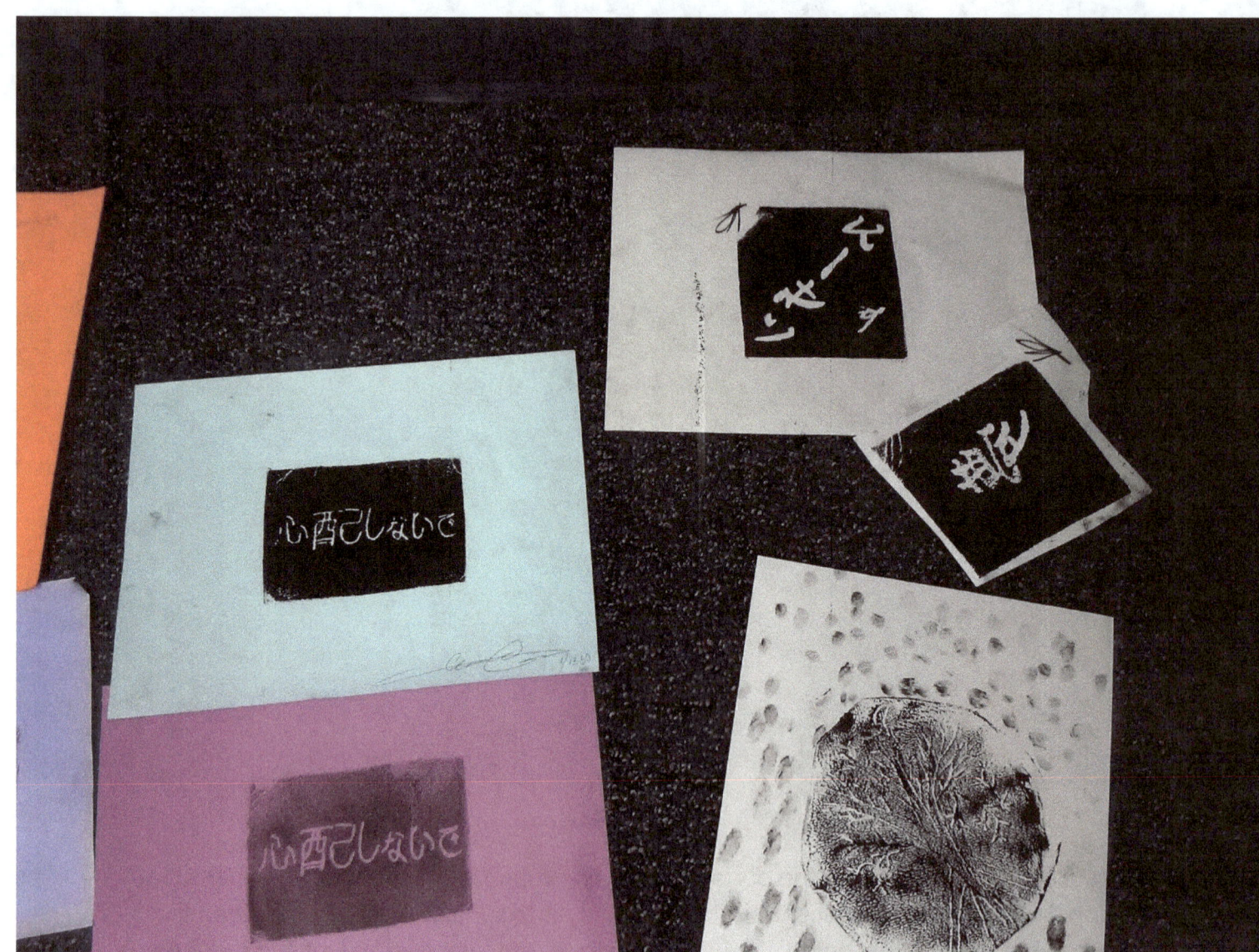

 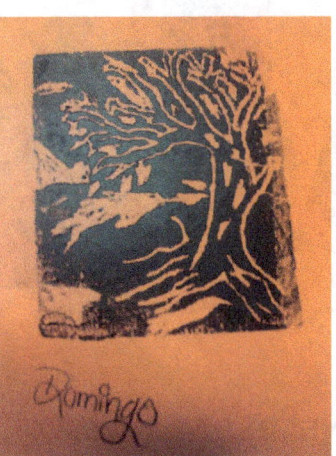

Block Printing

Estimated Time: Two class periods

Introduction:

Japanese woodblock printing originated in China and was brought to Japan in the 8th century. The first known text, the Dharanis, were filled with Buddhist verse, and most of the block printing took place in the Buddhist monasteries. Later in the 17th century, artists expressed the spirit of the day in print called the "Floating World." Block printing was a team effort of artists, publishers and paper makers.

Objectives:

Students learn the age-old techniques of Japanese block printing. Provided print material for inspiration. Each student is given linoleum and/or foam board material to carve out Japanese inspired designs. Students are also encouraged to come up with their own non-traditional designs.

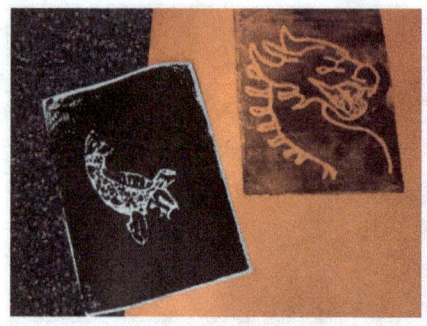

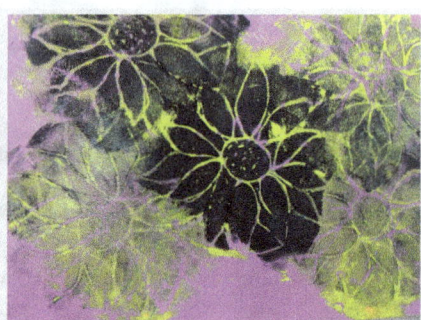

MATERIALS NEEDED

- Block Printing
- Woodcut relief
- Pencils
- Linoleum and/or foam board
- Paper
- Block printing ink
- Baron
- Brayer
- Printing plate

Activities -Students create their own designs inspired by Japanese block printing.

FL Standard(s) and learning targets in this section:

Enduring Understanding 1 **VA.912.S.1 :** The arts are inherently experiential and actively engage learners in the processes of creating, interpreting, and responding to art.

Estimated Time: 1.5 hours for each class

Instruction:

- Students chose images to create their own designs
- They sketch their image with pencil in their sketchbook
- Transfer image to a plate
- Print with ink on paper

Create a block printing book with a narrative.

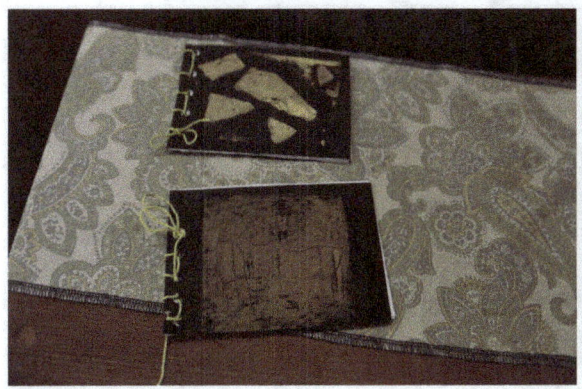

Creating Shadow Puppets

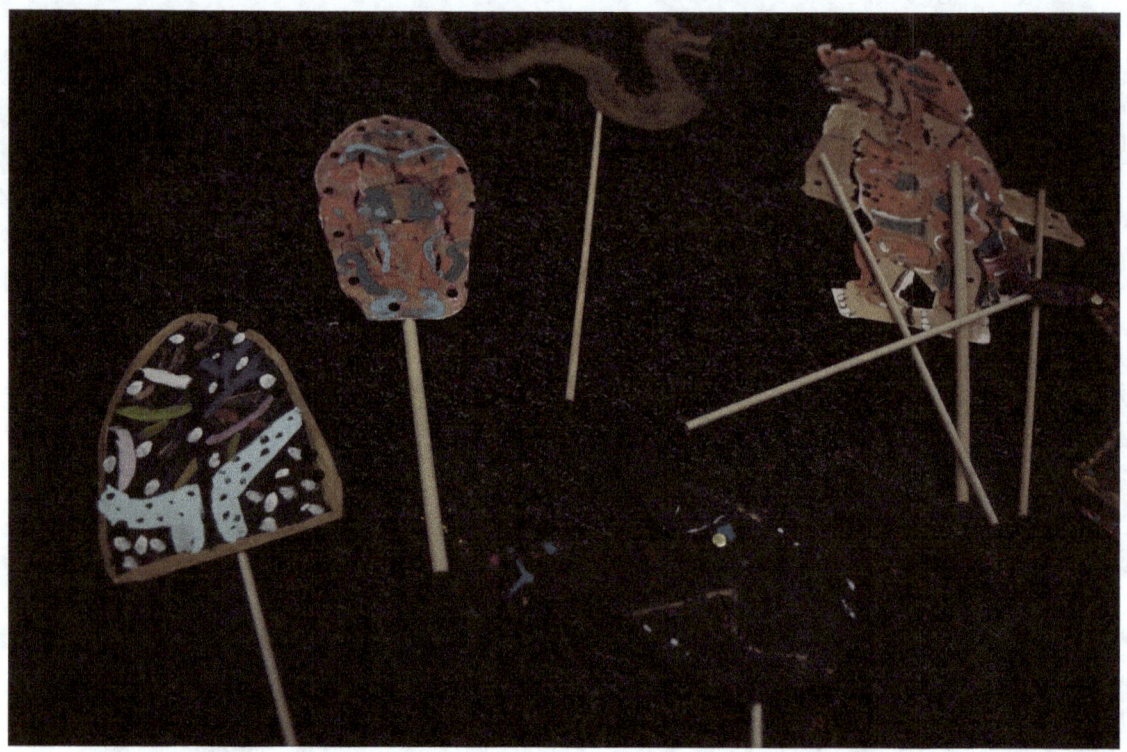

Introduction:

Introduction to new critical content/Review of previous critical content/P-12 Student Engagement

Estimated Time: 55 min class of 5 classes, M-F

FL Standard(s) and learning targets in this section:

Enduring Understanding 3 **VA.912.S.3** : Through purposeful practice, artists learn to manage, master, and refine simple, then complex, skills and techniques. read more

Instruction:

Students will learn the history of shadow puppets and create their own characters.

Alignment of Standards, Objectives, and Assessments

Students will be working together in groups.

Accommodations will be available according to the IEP recommendations.

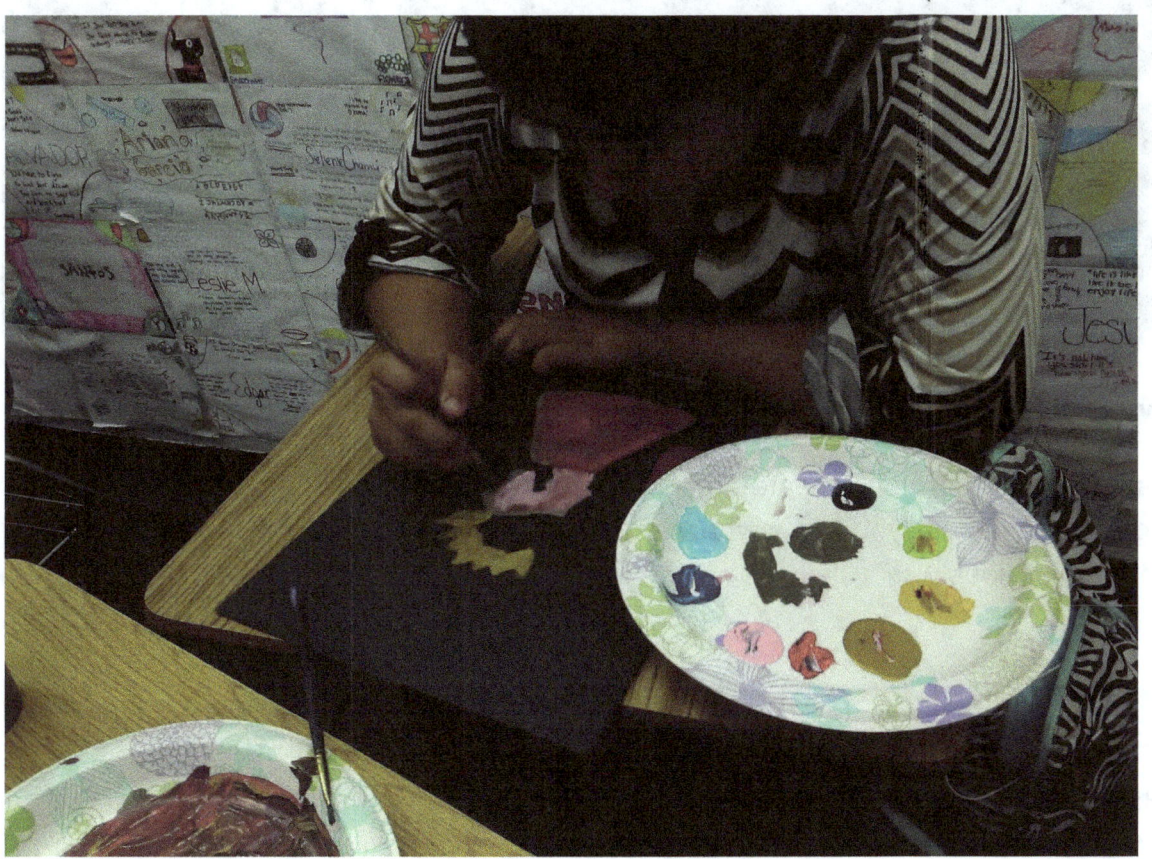

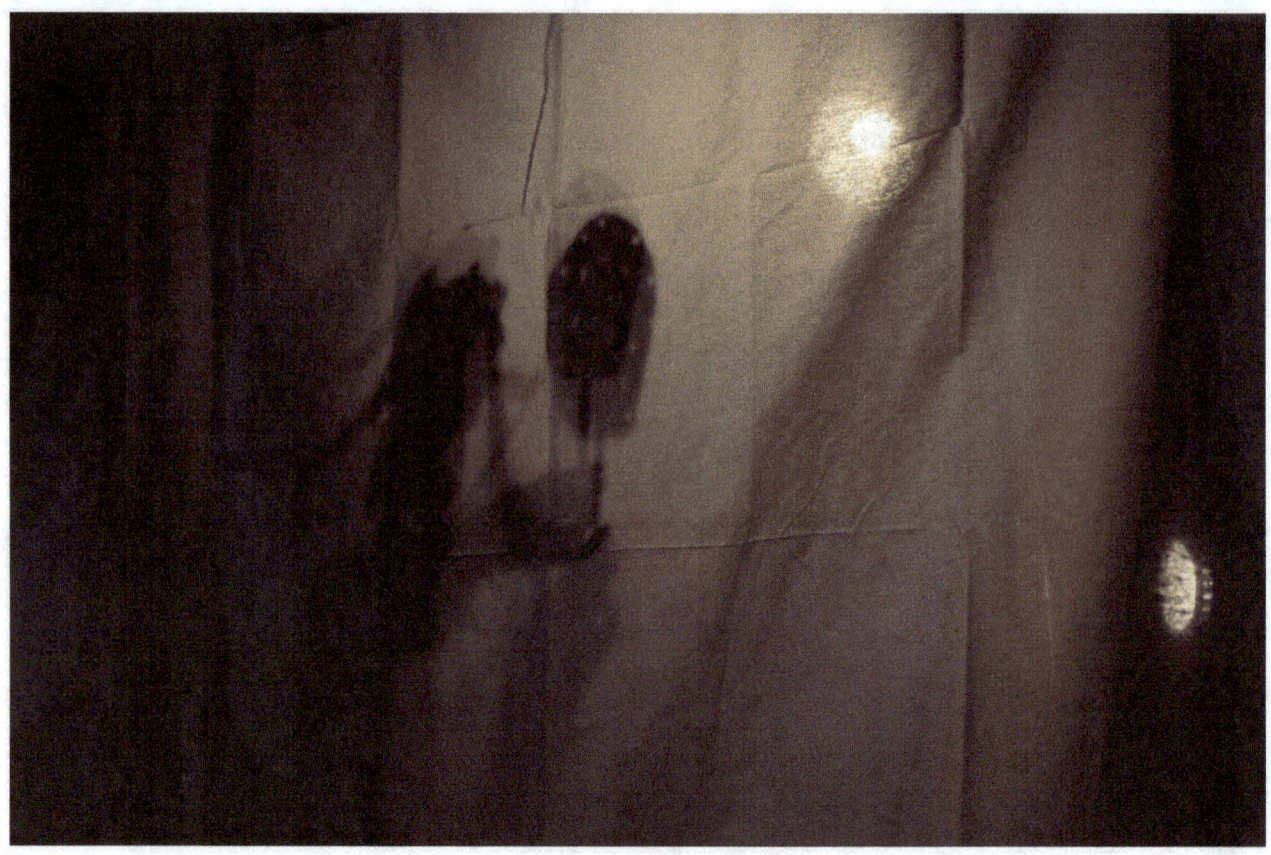

Shadows & Light Puppetry

Students work as a team and create a script for their characters. Once your team's roles are assigned, make sure you know what's expected. It's important to know your roles and take them seriously.

Activity:

1. Have students create a story as a group.
2. Students will then create their own puppets.
3. Students will set up a stage and lighting and perform the play.
4. **Guided Practice:** Share patterns and show students how to outline a puppet character.

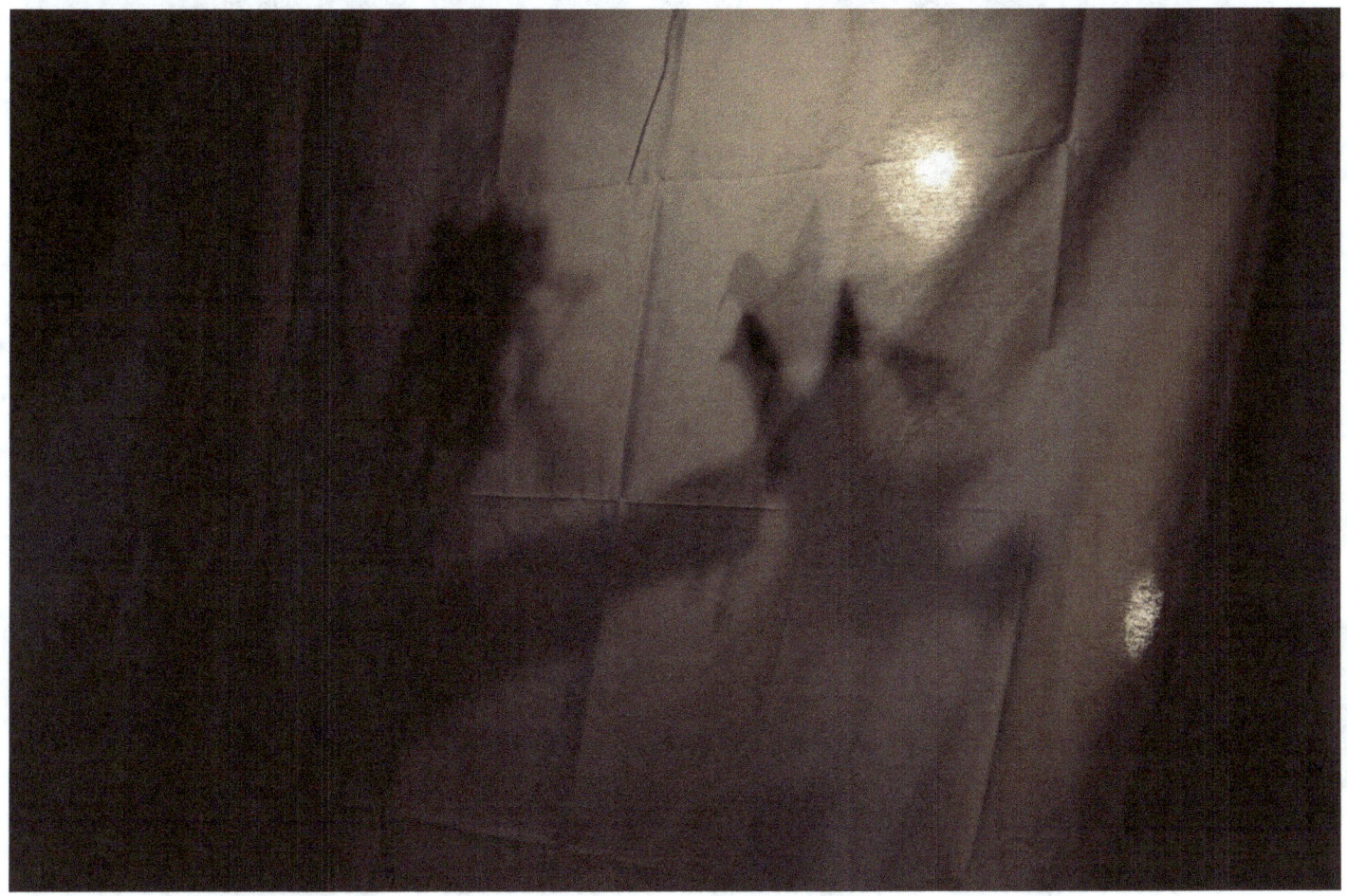

FL Standard(s) and learning target(s) in this section:

Enduring Understanding 1 **VA.912.S.1 :** The arts are inherently experiential and actively engage learners in the processes of creating, interpreting, and responding to art.

- Paired or group activities
- Practice
- Feedback from peers and teacher

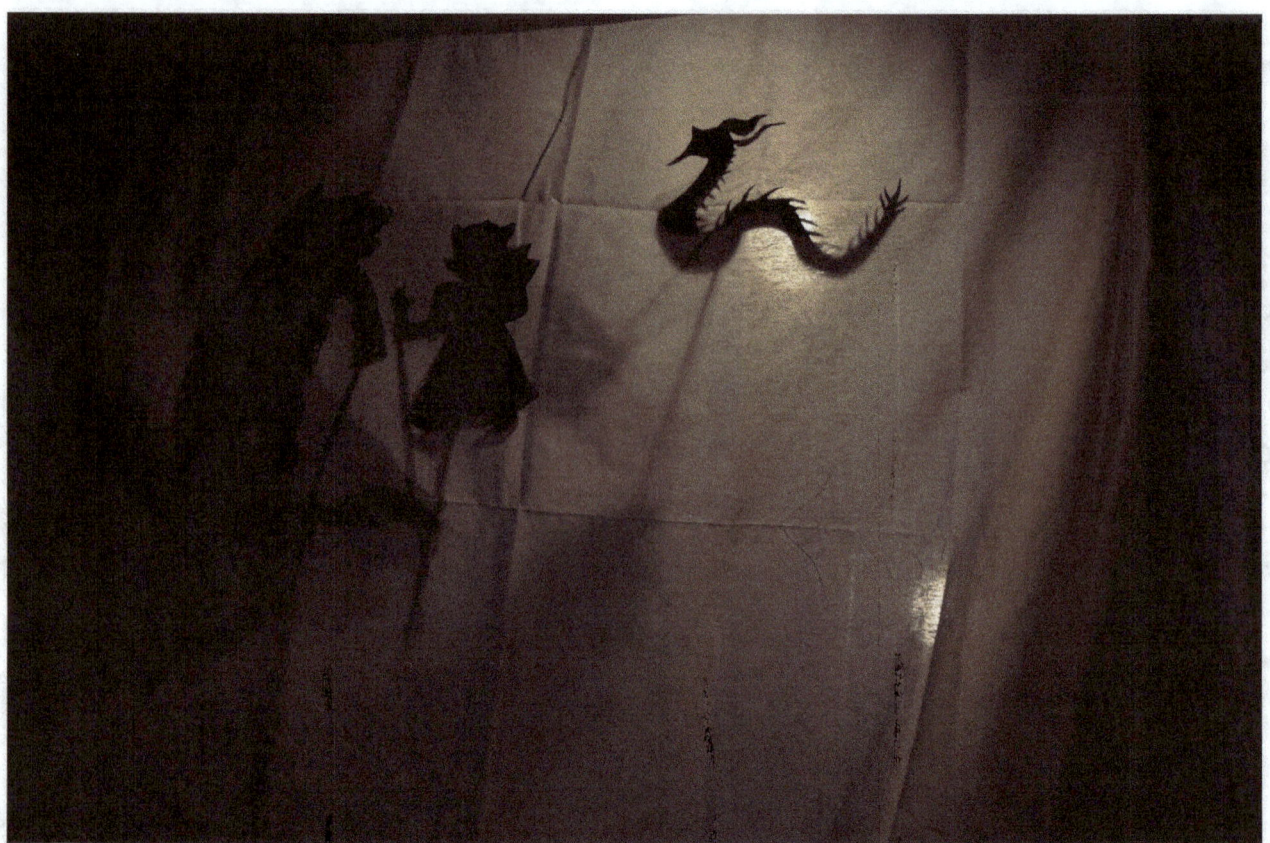

Advanced students can take on roles to assist with the production of the play.

Introduction to new critical content/Review of previous critical content/P-12 Student Engagement

Higher Order Questions/Activities (TPI 2.2)

List questions and/or activities that are in your introduction section and identify the level of taxonomy.

Analyze, Create, Apply

Students will analyze the shadow puppet play and then create their own dramatic story. Each student will write a story and then perform the play. There will be collaboration creating the plot and developing the characters.

Instruction/Explanation

Students are shown puppet plays and then given an outline to follow to create their own play.

List the FL Standard(s) and learning targets in this section:

Accommodations will be available according to the IEP recommendations.

Estimated Time:

1.5 hours

Include P-12 student first names

| P-12 Advanced Students Content, Process or Product | Advanced students can take on roles to assist with the production of the play. |

This is the final project: students will perform their shadow puppet play.

Performing the play.

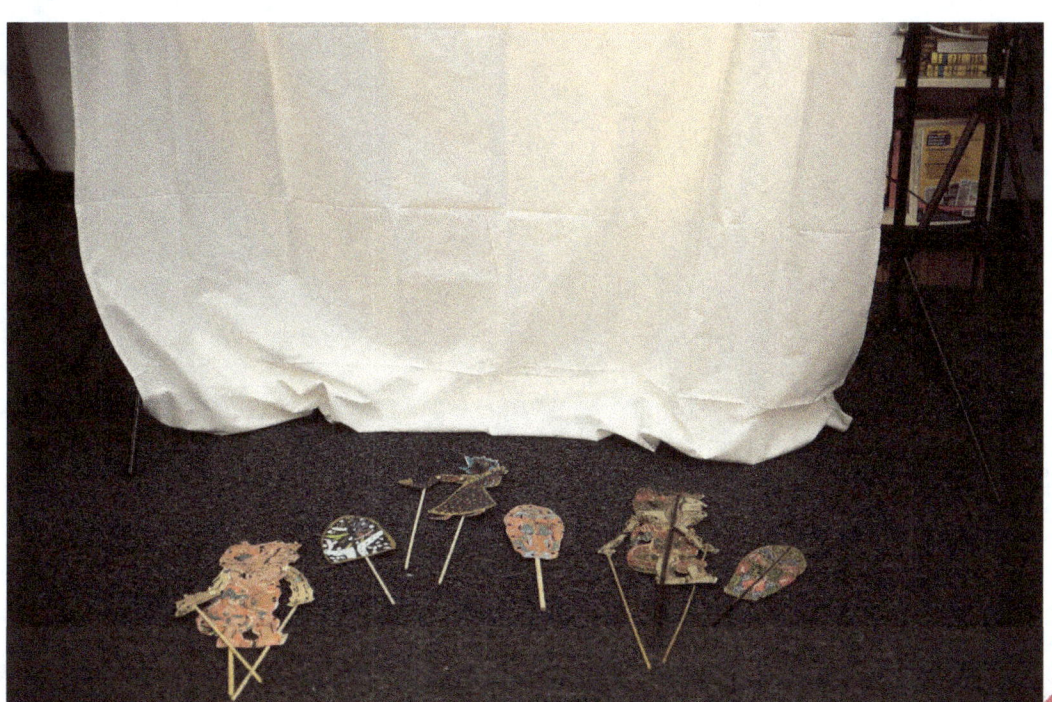

Summative Assessment/ Evaluation

This must assess the P-12 students' mastery of the FL standard and learning targets. Examples: final project, paper test, report, chapter test, etc.

Post-Art Assessment:

What is the Silk Road?

What area of the world is the Silk Road in?

What does the term "medium" mean in art making?

What art techniques are used to create Japanese block printing?

What is a shadow puppet?

What kind of stories are performed with shadow puppets?

What is stab binding?

Environmental Self Portrait

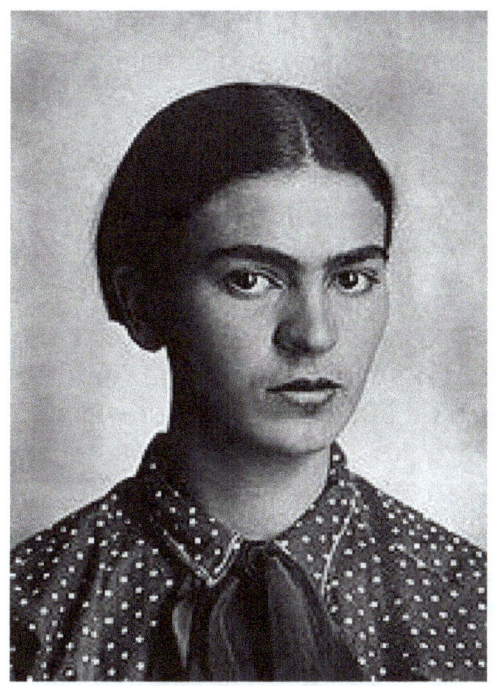 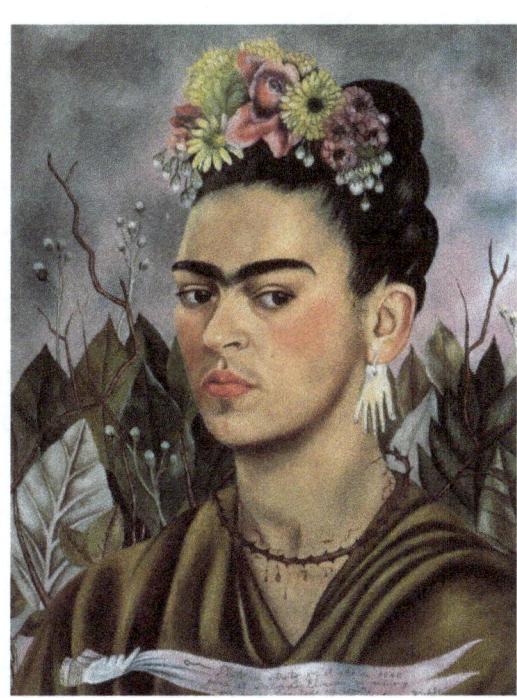

(Credit: Victoria and Albert Museum)

OVERVIEW & PURPOSE

Students learn about the artist and life story of Frida Kahlo. The lesson is meant to emulate the style and approach of Frida's work. Students learn to draw and learn art appreciation.

EDUCATION STANDARDS

1.0 ARTISTIC PERCEPTION

Processing, Analyzing, and Responding to Sensory Information through the Language and Skills Unique to the Visual Arts. Students perceive and respond to works of art, objects in nature, events, and the environment. They also use the vocabulary of the visual arts to express their observations. **Develop Perceptual Skills and Visual Arts Vocabulary** 1.1 Use artistic terms when describing the intent and content of works of art. **Analyze Art Elements and Principles of Design** 1.2 Analyze

and justify how their artistic choices contribute to the expressive quality of their own works of art.

2.0 CREATIVE EXPRESSION

Creating, Performing, and Participating in the Visual Arts. Students apply artistic processes and skills using a variety of media to communicate meaning and intent in original works of art.

Skills, Processes, Materials, and Tools 2.1 Demonstrate an increased knowledge of technical skills in using more complex two-dimensional art media and processes (e.g., printing press, silk screening, computer graphics software)

3.0 HISTORICAL AND CULTURAL CONTEXT

Understanding the Historical Contributions and Cultural Dimensions of the Visual Arts. Students analyze the role and development of the visual arts in past and present cultures throughout the world, noting human diversity as it relates to the visual arts and artists. 3.2 Compare, contrast, and analyze styles of art from a variety of times and places in Western and non-Western cultures.

4.0 AESTHETIC VALUING

Responding to, Analyzing, and Making Judgments About Works in the Visual Arts. Students analyze, assess, and derive meaning from works of art, including their own, according to the elements of art, the principles of design, and aesthetic qualities. **Derive Meaning** 4.1 Define their own points of view and investigate the effects on their interpretation of art from cultures other than their own.

5.0 CONNECTIONS, RELATIONSHIPS, APPLICATIONS

Connecting and Applying What Is Learned in the Visual Arts to Other Art Forms and Subject Areas and to Careers. Students apply what they learn in the visual arts across subject areas. They develop competencies and creative skills in problem solving, communication, and management of time and resources that contribute to lifelong learning and career skills. They also learn about careers in and related to the visual arts. **Careers and Career-Related Skills** 5.4 Work collaboratively with a community artist to create a work of art, such as a mural, and write a report about the skills needed to become a professional artist.

OBJECTIVES

1. History of Frida Kahlo self-portraits.
2. Students will learn the proper proportions of a human head.
3. Students will learn color-blending with oils pastels.

MATERIALS NEEDED

1. Mirrors
2. Paper
3. Pencils
4. Black markers/pen
5. Oil pastels or colored pencil

VERIFICATION

Steps to check for student understanding

1. Assessment test

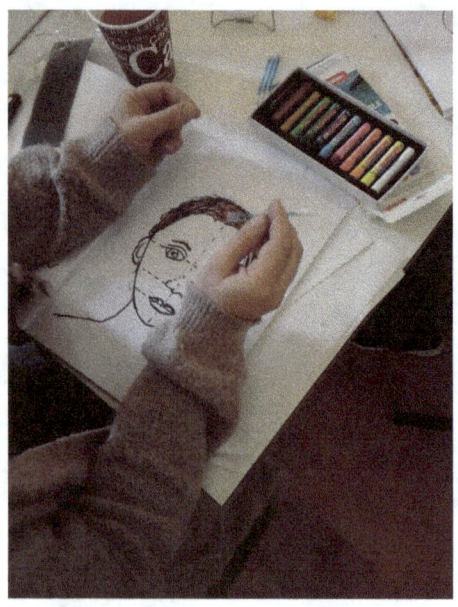 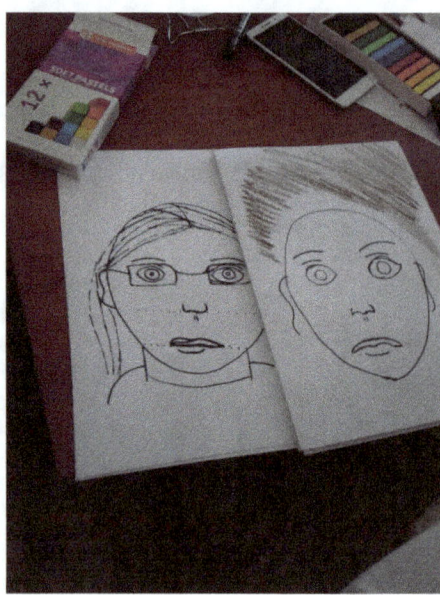 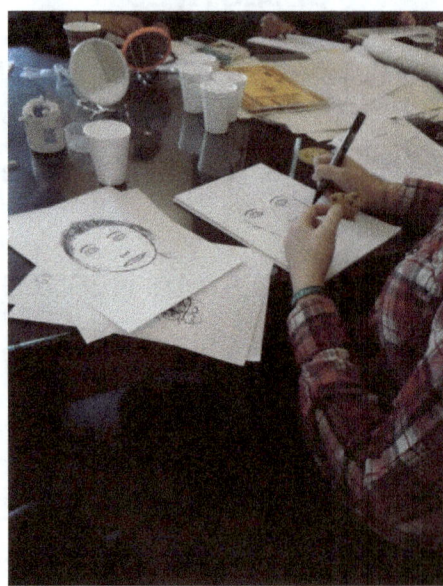

ACTIVITY

1. Students are given a pretest to check their knowledge on the subject.

2. Visual tools are presented in class such as samples of completed self-portraits and books about the artist's life. If technology allows, a video can be presented.

3. Students first learn general measurements of the human head and then they can create a second drawing using the proper proportions. Students are given mirrors to study their own facial characteristics.

4. Oil pastels or colored pencils are then applied to complete the drawings.

The lesson:

I will draw along with students during the Zoom presentation so that they will know exactly where to place the dots and draw the shapes for the eyes, nose, mouth and ears.

1. Measure your head and place dots on the paper
2. Draw an egg shape connecting the dots from your head measurement.
3. Place a dot in the center of the oval.
4. Place another dot between the the center dot and the bottom of the oval

34

5. Place one more dot between the dot you just placed and the bottom of the oval.
6. See example below.

Example:

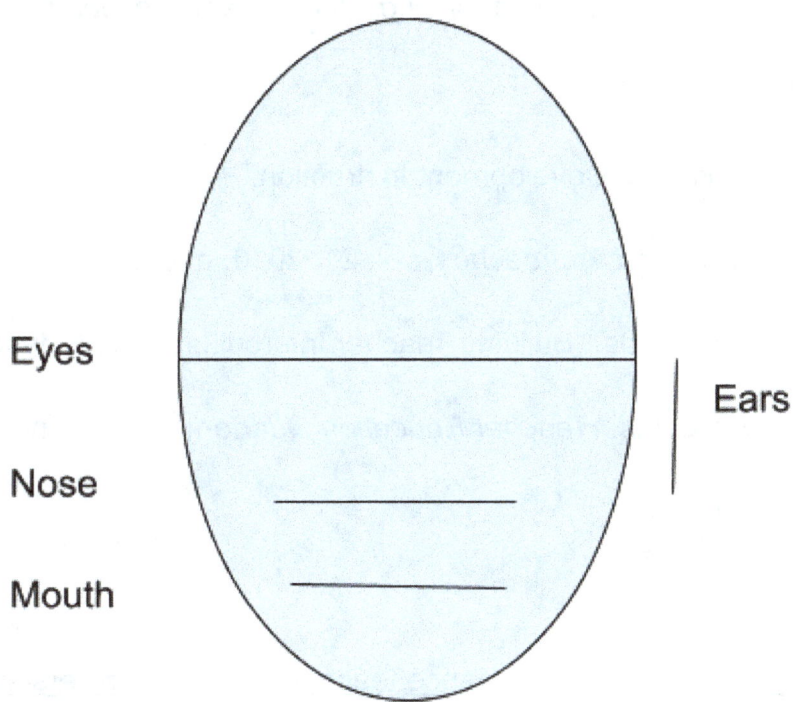

Bibliography:

Roxas, Kevin, and Laura Roy. "'That's How We Roll': A Case Study of a Recently Arrived Refugee Student in an Urban High School." *The Urban Review*, vol. 44, no. 4, 2012, pp. 468–86.

Saunders, William, and Claude Goldenberg. "Research to Guide English Language Development Instruction." *Improving Education for English Learners: Research-Based Approaches*, vol. 21, 2010, p. 81.

"Research to Guide English Language Development Instruction." *Improving Education for English Learners: Research-Based Approaches*, vol. 21, 2010, p. 81.

Smolcic, Elizabeth, and Jessica Arends. "Building Teacher Interculturality: Student Partnerships in University Classrooms." *Teacher Education Quarterly*, vol. 44, no. 4, 2017, pp. 51–73.

Web:

https://www.brown.edu/academics/education-alliance/teaching-diverse-learners/strategy-ii

http://www.lemongroveoralhistoryproject.com

(Credit: Victoria and Albert Museum)

Photographs by Pamela Calore

www.ingramcontent.com/pod-product-compliance
Lightning Source LLC
Chambersburg PA
CBHW080855170526
45158CB00009B/2744